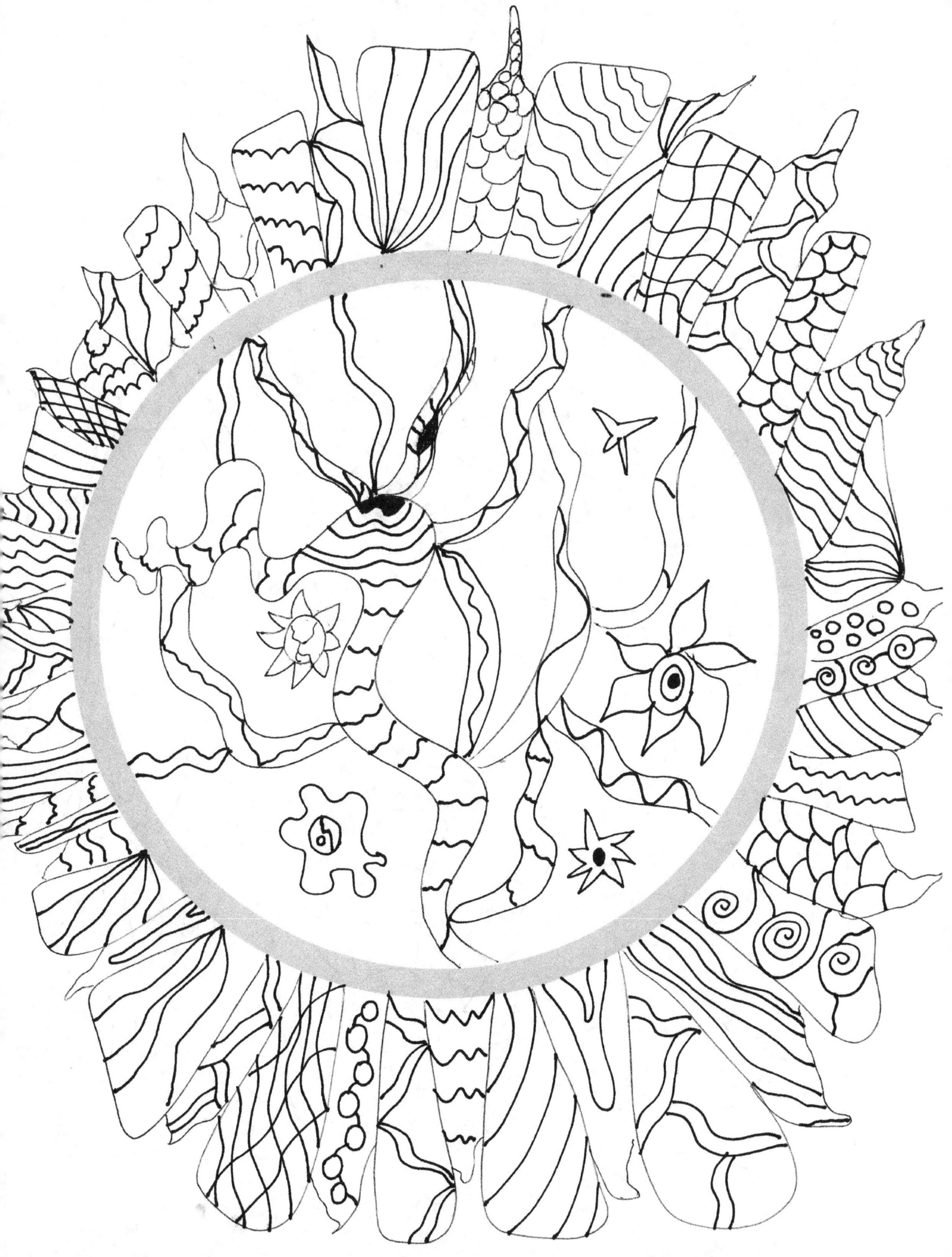

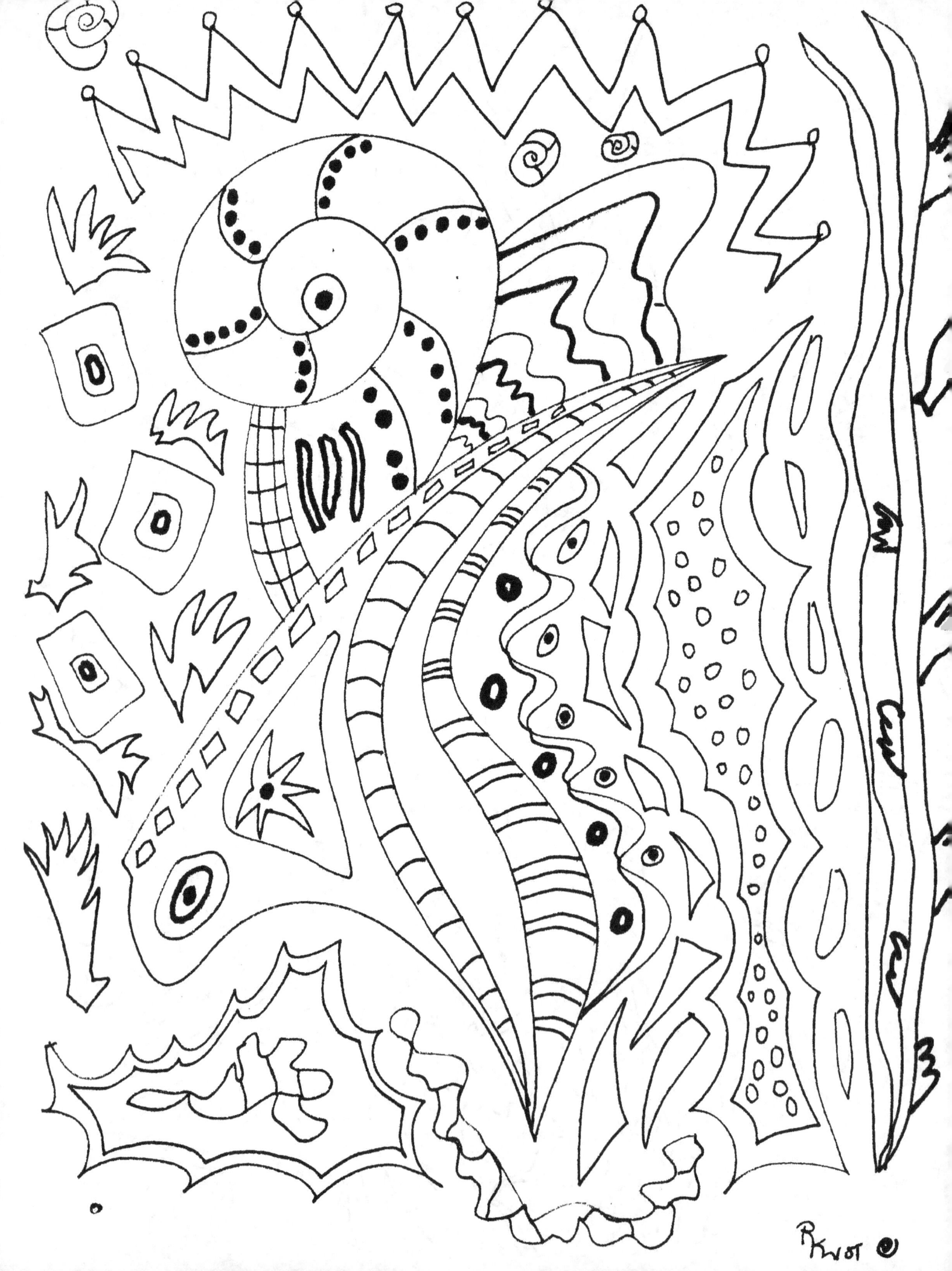

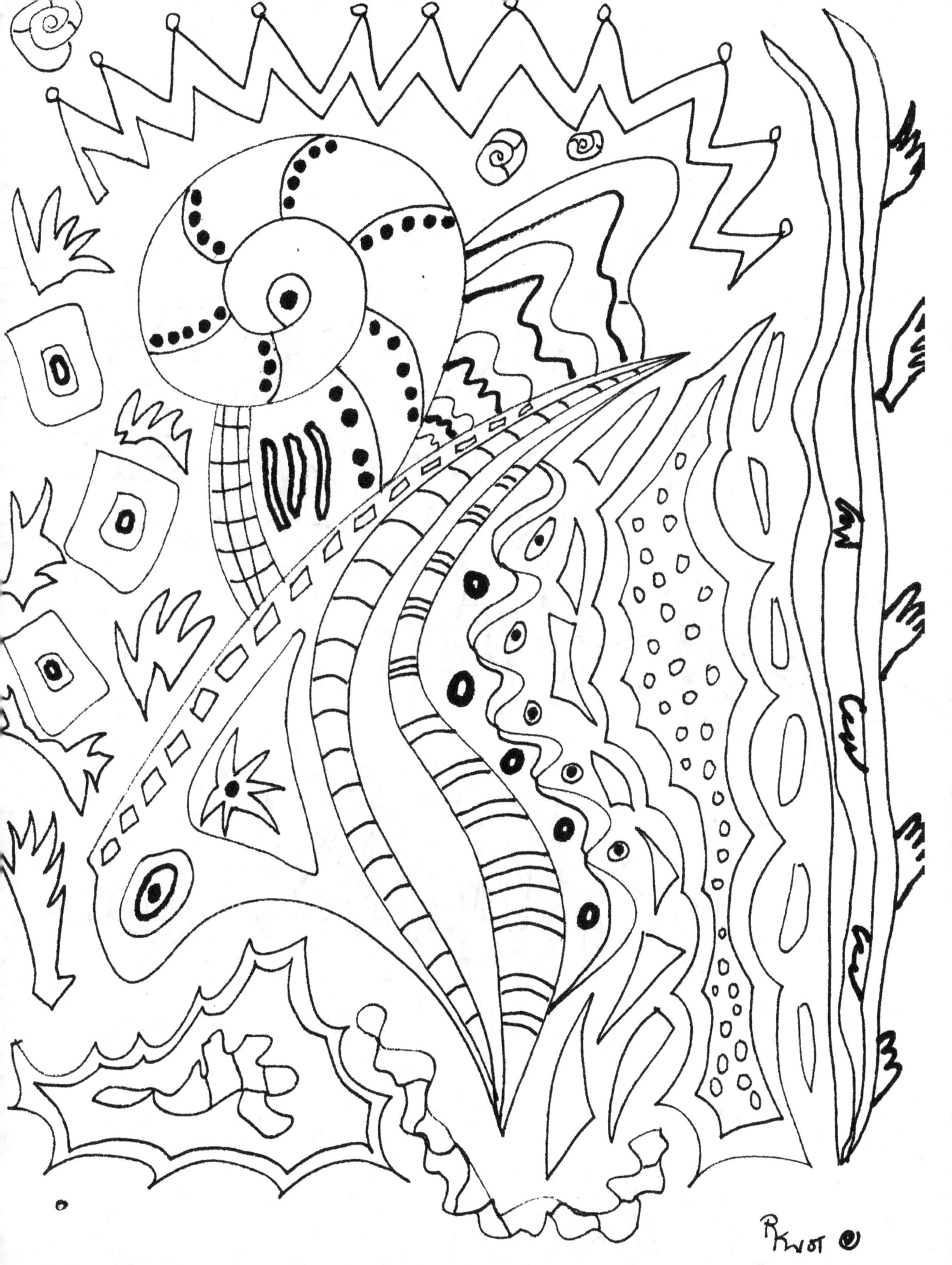

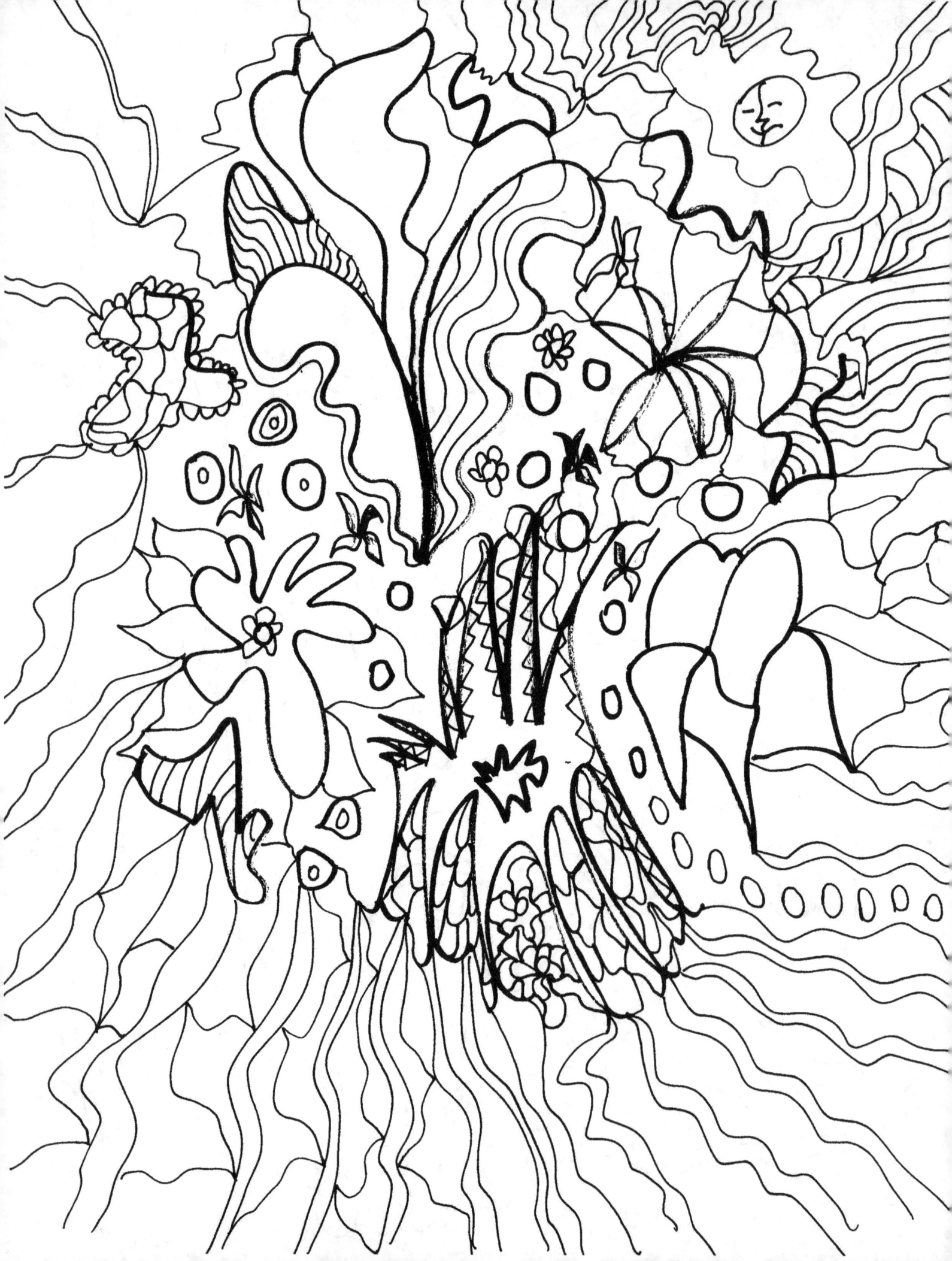

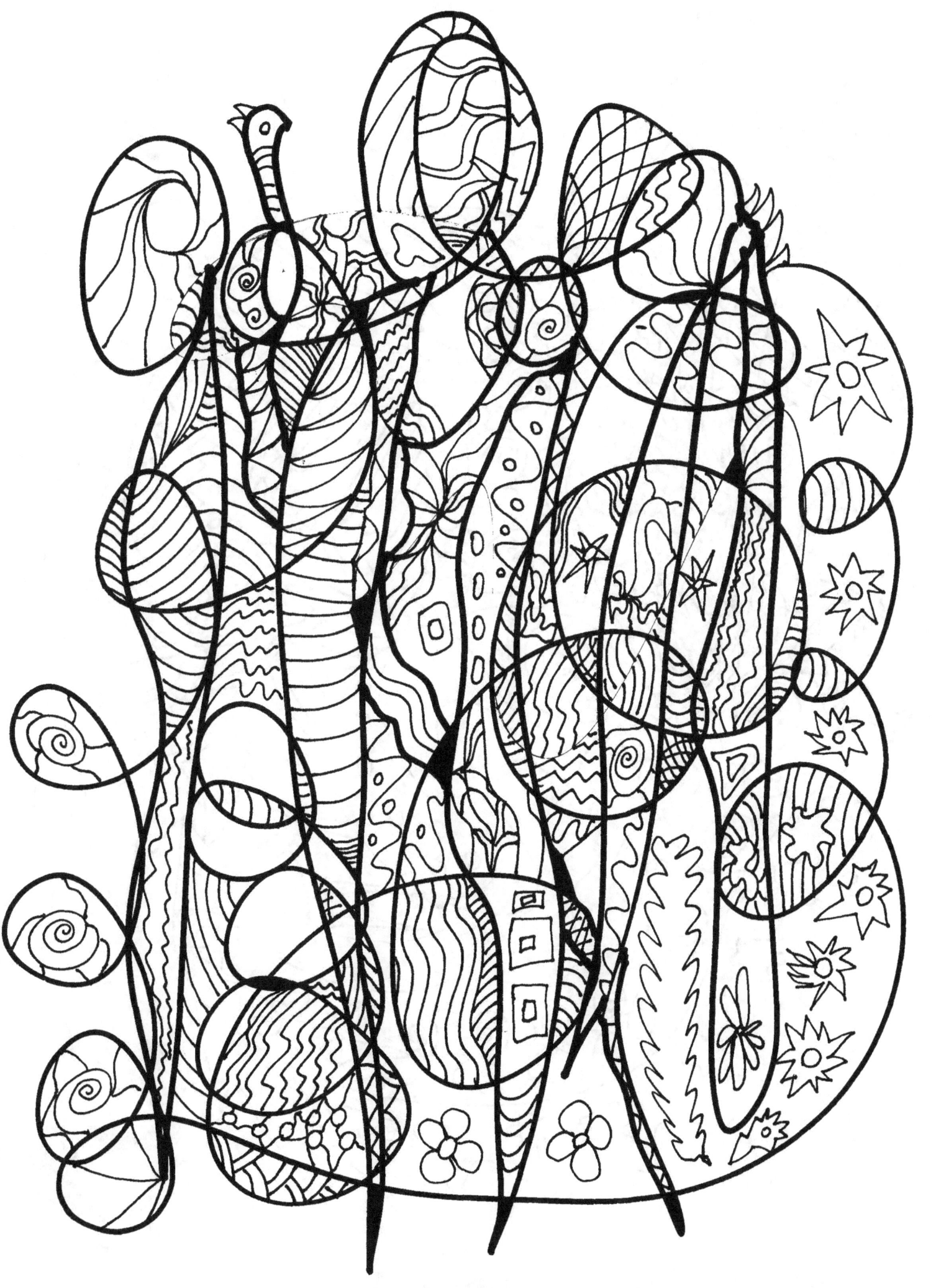

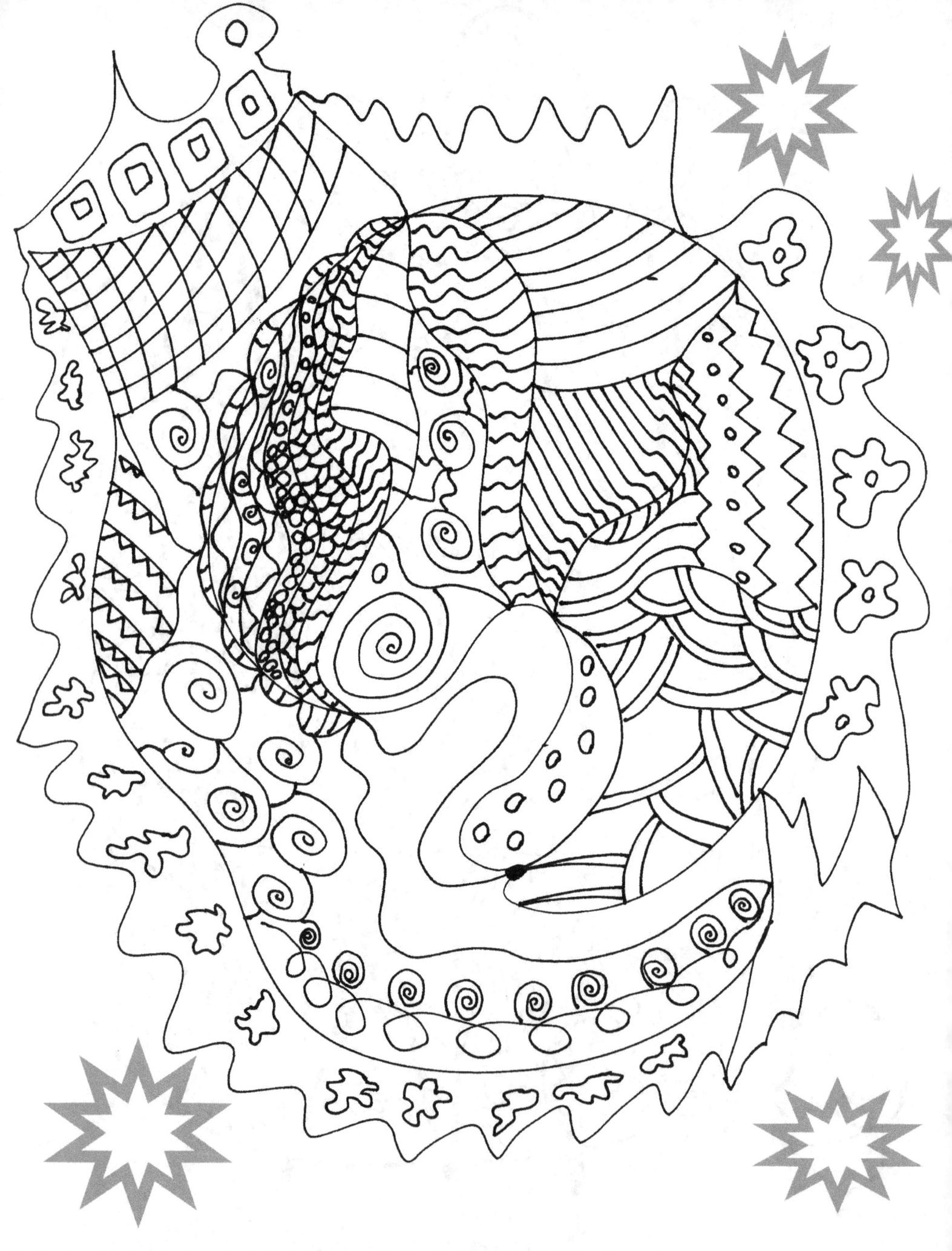

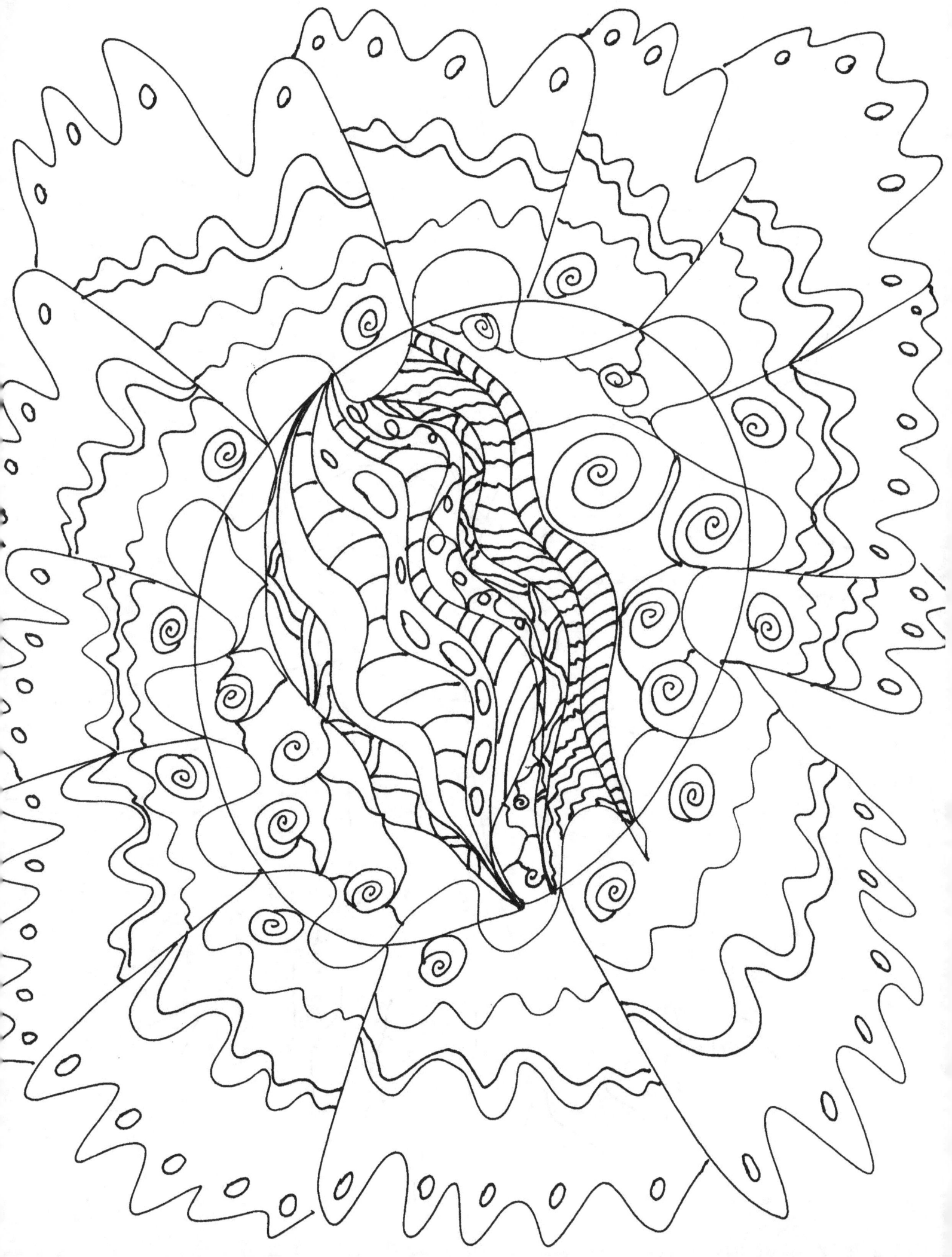

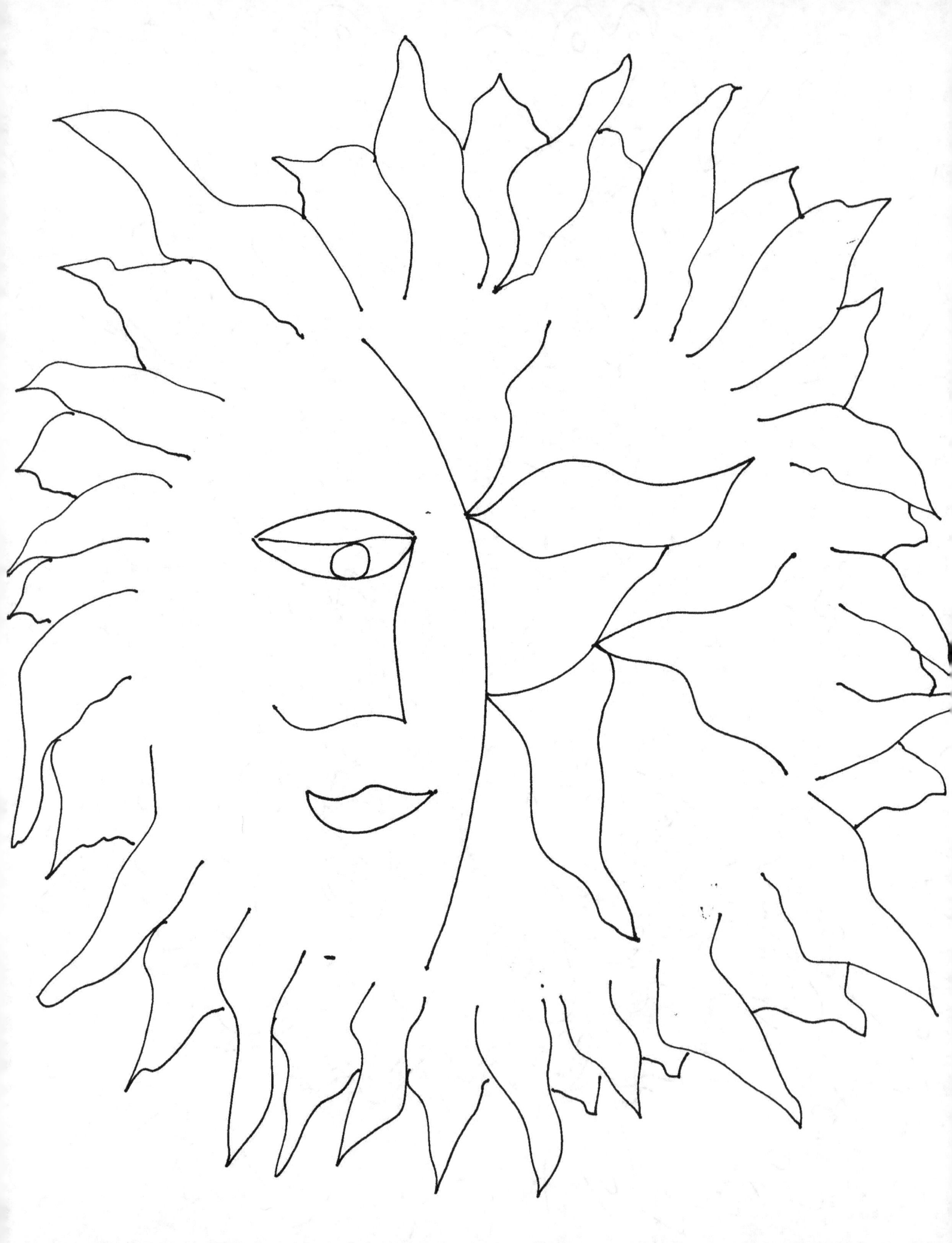

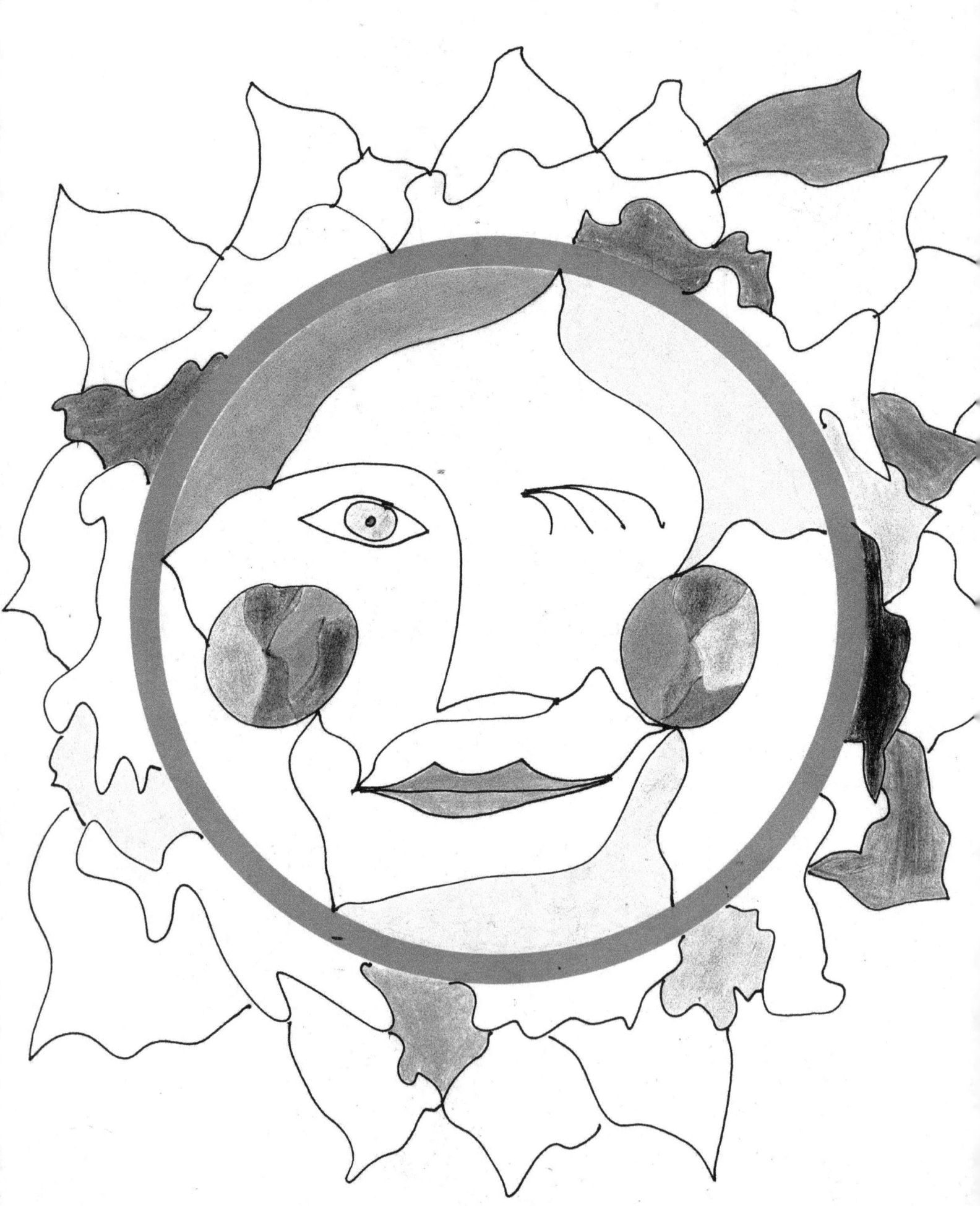

*Rosalyn Kliot is an award winning and published artist currently residing in Oregon. Her works have been shown and or sold nationally and in a travelling exhibit in Japan. She has been juried into numerous gallery exhibits in Chicago, Los Angeles, Oregon, Washington, and the Springfield Museum in Oregon. She studied formally, earning a B.A. degree in art while on a full ride scholarship at Roosevelt University. She has also studied with Don and Alice Baum of the Art Institute in Chicago. Her works can be seen on youtube and fineartamerica.com.*

PINK COLLAGE PRESS - KLIOT STUDIO

cc: All portions of this book are subject to artist copyrights, and may not be reprinted without artist permission.